NAMASTE
Bitches
a poetry journal

By Amy Rodeffer Thompson

Namaste Bitches

A real, raw interpretation of life's journey from awakening to... so now what?

bossibly
Edgewater, Florida
Bossibly.com
amy@bossibly.com
www.bossibly.com
443-904-2746

Ordering Information:

Special discounts are available on quantity purchases by corporations, associations, educational institutions, and others. For details, contact bossibly above.

Printed in the United State of America
First Edition

ISBN978-1-5136-8879-4

Publisher: Winsome Entertainment Group LLC
Cover Design: Courtney Fraas

Table of Contents

Prologue

A little context behind the title: **Namaste** – a greeting of respect and thanks, a phrase commonly used at the end of a yoga class generally meaning "the light in me honors the light in you." Spiritual stuff. **Bitches** – a term of endearment among friends who don't take themselves too seriously; when uttered, usually indicates shit is about to get real. Also, commonly considered a curse word.

The juxtaposition of the two is very me.

This poetry journal is not meant to be inspirational; rather, it was inspired by reality – MY reality. I will cover some ugly cry moments, the ones you typically keep to yourself and don't say out loud. The icky, sinking-pit-in-your-stomach, too-embarrassing-to-share stuff. THAT is what this is about. In sharing deeply personal thoughts & feelings, I hope it helps someone to feel not so alone.

Where we drop into my story: I was living an ordinary life. I chose the Good Girl path and made mostly NiceGirl choices. At one point, I awakened from my self-induced numb misery, and realized those choices no longer served me. These poems come from the period immediately *after* that decision. I don't know what it'll take for you to get to there – everyone is on a different path – but these poems describe what happens beyond that tipping point.

How to use this book: I give you permission to do whatever you want with it. My intention was to make this something you could journal within, doodle on, or rip out a page and hand it to a friend you think might need to hear the words. **If feelings come up, write them down. If tears well up, let them fall onto the pages.** Admittedly, the old me would NEVER do such things, but I now realize I am allowed to do things like that, so I'm letting you know, in case you weren't aware: you can, too.

Structure: I've organized the poems based on my personal Core Desired Feelings – how I want to feel: Luminous, Divine Purpose, Power, Open, Joy. These describe what GOOD feels like to ME and I look for opportunities to feel this way all the live-long day. Identifying these turned my life on its head, in the most delightful way. Danielle LaPorte's "The Desire Map" is seriously good stuff.

Note: I believe in something bigger than me. I use a variety of terms: God, Source, the Universe, etc. I use these terms interchangeably, but all point in the same direction.

Luminous

This little light of mine
Used to be too scared to shine
When mine met yours it would run and hide
But in time I came to find
I wanna shine so bright
It makes this whole world smile
And pay back the beautiful feeling
That allows me to be
Whatever I wanna be
And I am gonna be
Free and easy

– Beautiful Chorus

This is what a Mid Life Crisis looks like?

When I was a kid
I thought a midlife crisis was for men
A knee jerk reaction to overwhelming responsibility
Loss of adventure
Symbolized by the purchase of an impractical car
Perhaps a dalliance with a fling
One last dance with virility and youth

Then I roll up on that life stage
And all hell starts to break loose inside of me
An existential crisis
The kind they make movies about
Where the female protagonist "finds herself"
Ugh, really? So cliche
Yet, here we are

This is not the superficial midlife crisis script I had in my head
This is vastly different
A disintegration of my exterior
The face I presented to the world
Leaving what was just beneath the surface exposed
Terrified - I'd busted my ass to hide this!
I'm literally falling apart
And like Humpty Dumpty
I couldn't put myself back together again

I'm hindsight I can see
My vitality had been caged
Cruelly by myself, societal expectations
And a heaping spoonful of I simply didn't know any better
This was a necessary falling apart
In the moment, it felt like I was going crazy

Emotions - deep, raw, coming to the surface
Triggering panic
Sensation of loss of control
Fear of losing my mind, losing it all

A few breadcrumbs laid
Crawling my way to make sense of this new-found crazy
Inch by inch
Uncovering my sense of knowing
Feeling my way in the darkness
Eyes adjusting to the low light
Realizing I can see more than I thought

Guides, lighting the way
The words of Danielle LaPorte, Brene Brown, Glennon Doyle, Tim Ferriss
Trusted friends holding space while I explored what was being stirred up inside
Time alone, listening to myself for once

Once you wander down this path
There is no going back
You cannot unknow freedom to think for yourself

So yes, I've had a midlife crisis
And I am grateful
My burdens are much lighter
Life is sweeter
My perspective has shifted significantly
Less doing, more being
Less worry, more present

These words seem simple, basic
Like a cheesy motivational quote
Insufficient to capture the metamorphosis

But maybe that's the point
I broke myself down to get down to what matters
And what matters is very simple

Amy Rodeffer Thompson

Mourning

I had a life
I'd built it from the ground up
Cultivated for decades
The making of a well-liked person

And it was a sham
A hair shirt
Ill-fitted to the person I'd become

Each element, carefully selected
Placed gingerly into just the right spot

And it brought me zero joy

Here I stand
On the precipice
Between the old and the new

And tears are slowly streaming down my
cheeks
I am mourning
My former life that was predictable
And curated
And safe

It sucked, but I knew what to expect

I'm mourning that sense of knowing
What tomorrow will bring
Being in control
Feeling safe from harm

It was all an illusion, of course
None of us ever really know
Nothing is guaranteed
We are never completely safe
And being in control -
I could write a book about how wrong that
part was

So now I'm taking a moment's pause
Beneath the cool shade of The Great Pause we are
all under
To allow myself to grieve the old
To love that version of me
Who was doing her best when that's all she knew
And appreciate the strength that came from that
journey
Unshackling myself from those self-induced limita-
tions

Mourning what was
To make room in my heart
For new

Amy Rodeffer Thompson

What happens then?

There is a lot of talk about self-care
Courses on setting boundaries
Tools & techniques to get out of your own way
All designed to help you live more happily

What happens then?
Once you have cleared your chakras
Started healing your inner child
Establishing healthy practices
Moving away from that which no longer serves you

People around you may squirm a bit
Change is good... AND can be uncomfortable

The old dance screeches to a halt
You no longer want to continue
So you stop participating
Others are... confused. What happened?
Sometimes confusion morphs into fear
Occasionally lashing out with anger

The point at which your growth gets tested the most

When those you love respond in an unexpected way
First instinct is to fall back into old patterns
Make everything is "safe" again
Or you are inclined to double-down
Ramming your newfound voice down someone
else's throat

Oh, beloved. I know this feeling
Vulnerability in your sleeve
Unclear how best to protect your tender heart
The best protection is no protection
Your old armor only harms you now
Now you will be engaging new muscles
And won't rely on the old ones as heavily

What helped me in those early days
Was the knowledge that my mind and soul were
ahead of my body

My body was freaking out
That didn't mean my resolve was wrong
Just foreign to my more slowly evolving
body

I coped by using lots of awareness
Acknowledging my heart felt like it was
literally breaking
It wasn't. But it sure as hell felt like it

The tears, Lord... so many tears
Would they ever stop?
Was I actually dehydrated from all of the
damned crying?
I wasn't, but I did take that extra sip of
water just in case
Memories that felt like an actual gut punch
Will I get through this? You will

It feels like the waves won't stop
But gradually, over time, they will
Or the body will stop manufacturing them
Or you'll get stronger to withstand them

It happens, and then you are living it
Your new truth
And this, my love, is the truly powerful part
You get so good at overcoming
You willingly go looking for more
More hard shit to conquer
The battle is 100% an inside job
A joyful, playful, curious existence
This is what happy looks like

So hang in there
I know it sucks right now
Sometimes the only way is through

Amy Rodeffer Thompson

Ugly Truth

We all have them
Skeletons in our closets
Those regrets we carry
Emotionally charged, shame-stained events
That we fervently wish had never occurred
But they did

For me, those were under strict lock & key
Never to be disclosed, never to speak of
Mine to guard as though my life depended upon it

It did, sorta
But not in any way I could have imagined

My Life depended upon me doing the exact opposite
I could not truly live until the shame came out
Ugly, raw, unpolished, embarrassing
The whole thing had to tumble out
Not to be exposed for others to judge
Although they will
But rather for me to embrace that which is a part of me

A part denied is a neglected child
Constantly begging to be soothed
Relentlessly crying out
Pay attention to me
I need you

Not heeding those cries, I'd developed indifference
Reasoning that some things are better left well enough
alone
Rationalizing that I'm past that now
It's old news, no longer relevant

Logical thoughts, sure
But if you keep sweeping things under the rug
Eventually you'll trip over the lump you've created

So after tripping and stumbling and
falling flat on my face
I stopped sweeping
Actually looked at what I was avoiding
so hard

Yes, I had made mistakes
Sitting in my mess I felt shame
But I noticed a bunch of other stuff too

Releasing that brought healing and
relief to others
In all of my hiding, there had been unin-
tended consequences
Denying my reality meant denying it for
others as well
Assumptions made that things were
perfect when they were far from it

Transparency is neutral
At its purest form, it is affirming

This is true for people, for countries, for
history
Pretending doesn't serve the greater
good

Amy Rodeffer Thompson

After the facade, then what?

I resisted being myself for years
Terrified to do so
Fearful, with the facade removed
There would be nothing left of value
A shell of a person
Worthless, vapid, soulless

I kept my opinions to myself
Locked tightly inside
A judgmental, scarcity-minded fool
Nice, but not kind
Desperately hiding behind helpfulness
Needy to be useful
To justify my existence

I ascribed to the philosophy of
Fake it 'til you make it
Exuding a cool confidence
Simultaneously terrified to be found out
For the fraudulent person I felt I was
I did not have my shit together

Miraculously, I did it anyway
Kicking and screaming at times
I burned it all down

Good news - I am still alive

What happens when you drop the facade?
Stand naked, exposed
Simply exist as you are
I don't know your path
But here is where I stand on mine

Eventually the terror subsides
Hard to imagine in the beginning
But living without that hair shirt is not only possible
At some point it will no longer fit

Time alone feels good
I fought it, relentlessly filling my time helping others
Gradually relaxing into moments of solitude
Letting myself be alone
With my thoughts, feelings

The fears around being nothing were
unfounded
My true personality is quirky
I have a unique way of seeing the world
My sense of humor is downright silly
I can switch easily to absolute sincerity
My mind has been quickened, awakened
I have a lot to share with others

I am far more sensitive than I ever imag-
ined
My feelings are deep and intense
My bullshit meter is ever vigilant
On myself as well as others
Gravitating towards truth always
Curious when things feel off

Curiosity
Probably the single most useful tool on
this journey
Curiosity keeps me open
An endless game of exploration
A playful approach to hard things

So yes, dropping the facade is doable
Painful, yes
Enlightening, hell yes

Amy Rodeffer Thompson

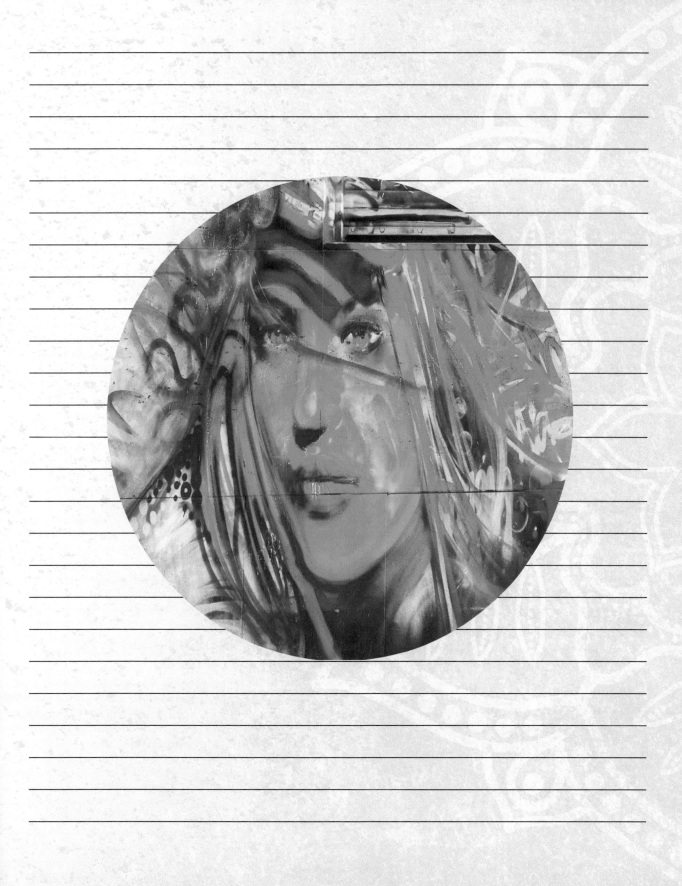

Causing Waves

Rebuilding of self
Is not a one and done
Over and over
Phoenix, ashes, repeat
Difficult, but an inside job

Then comes the external reflection
Others responding to changes in me
It's been tough
Tough to hear the words
To feel what's beneath them
Dawning realization

I was a constant, a rock
Consistent to a fault
While unhealthy, setting expectations
Of accessibility, always there

I've changed behaviors
Which is stirring up emotions
And people are reacting
They want to go back to how things were

I'm no longer back there
I'm here now
I don't want to go back
There is nothing there for me

I am protective of my energy now
I choose to live vulnerably
I'm nurturing myself out into the world
I'm delighted by what I'm uncovering, discovering
I surround myself with people who make me feel safe to be myself
Who are kind
On their own path to heal themselves

I now know when someone is treating me like shit
I can feel it
I can see that is their habit - encouraged by my old habits
I taught them how to be with me

The mere whisper of me drawing a boundary is terrifying
A challenge to me and the other

I want to live softly
I no longer act tough to fit in
Sharp words now exhaust me
I want to spend time with you only when I feel strong enough

I want to live in alignment with myself
I no longer care about others' expectations for me
Your concern is a reflection of yourself, not me
I find it wearisome to receive

I'm tender towards the other
They are confused
Their emotions are coming out messy
I have changed and they don't understand

I don't owe anyone anything
Radical language
A raised eyebrow of disbelief from the other

No expectations
There is nothing more kind
And freeing

Amy Rodeffer Thompson

What Am I Doing Wrong?

I've said the words numerous times
Upon reflection I now see
The meaning behind them can vary

A quick check-in on my basic needs –
Am I tired or hungry?
These are often the root cause of consternation
The easy path is always a good first step
Often overlooked by a busy lifestyle
So focused on achievement, accomplishment
Numb to my own basic human needs

As a recovering People Pleaser
It could be me taking on other people's stuff
This takes mental energy to resolve
Teasing out what is mine and what has nothing to do with me
Sufficient to glean what insights I can about myself
I am teaching myself, with practice, to leave the rest

Sometimes, I'm hiding the truth
What's wrong with me really means -
What the hell is wrong with you

Righteous indignation thinly veiled
Frustration abounds, and I need someone to blame
I feel helpless and am grasping at the injustice of it all
Too proud to allow myself to admit I'm scared, I defer to anger
It feels better to be mad at someone, something
Bitter tears in my eyes, I rail against a system stacked against me
Locked in a self-imprisoned cage, I get nowhere

The truth feels like unexpected ice-cold water to the face
Shocking, unpleasant
Why on earth did you say that?!?
Response: you asked what you are doing wrong.
There's your answer

Flash of anger
But I worked so hard, did everything right
That can't be it, there must be something else

This sucks
I need to get out of this conversation right now
Fuck this
Why do I even bother
I'm out

Underneath it all
My ego taking a big ole bruising
It may take me years to realize I am running
Running away from the truth, MY truth
Too afraid to face my own fears
It feels overwhelming
To go there feels as though it might actually kill me
Suffocated by the shame

I step mindfully now when I hear myself ask – what am I doing wrong?
I know there can be many layers beneath
Sometimes I merely need some calories
Other times, there is something much deeper at play

When I hear myself ask
I now move trembling, but headlong towards the truth
Nothing can be worse than what I've already faced
Even if in the moment it feels like I'm dying
My physical self is intact, it's just my ego
My ego was never supposed to be in charge anyway

Amy Rodeffer Thompson

The Responsible One

In order to be taken care of
I had to take care of myself
That's how I approached life
Only myself to blame if things didn't work out

That was the fire that propelled me forward
Chasing achievement to ensure I would not be left
destitute
An unfair burden to others
No way, not me

At some point, the chase lost a bit of its luster
I was getting tired, running out of steam
That fire was lacking something
I assumed it was me – I wasn't strong enough, deter-
mined enough
So I doubled down
Forcing myself to be more disciplined, focused

Eventually, I had to look elsewhere
Why had I taken on so much responsibility, really?
This was an uncomfortable question to ask
I squirmed, fought it, diminished it
But eventually, I heeded the question

The query illuminated things within me I really didn't
want to see
My "strength" was a cover-up of fear
My "independence" was me being a martyr
Me "being the responsible one" made me bitter and
lonely
The people in my life who "wronged me"
I had conditioned them to treat me that way

With each realization I experienced pain
Certainty evaporating
My tidy black & white world, obliterated

Now what?
Thankfully, an insight
There is, and never was, anything wrong
with you
You are a lighthouse, your light is merely
dimmed
Covered up with self-protection
You simply didn't know any better

I'd spent decades adding layer upon layer
of armament
Now it was time to start excavating
See what's underneath
Blind faith there was actually something
there worth finding

This self-protection is like fascia
Encasing every element of me
Sometimes stuck, immovable
Unable to be dislodged without
discomfort
A variety of approaches required to
regain freedom of movement

To regain freedom of movement once
again

I'm still excavating, but my light has got-
ten appreciably brighter

Less victim, more joy
Less certain, more curious
Less busy, more present

There are moments now when I don't
know which way is up
But life feels lighter, more free
And I'll take that trade-off any day

Amy Rodeffer Thompson

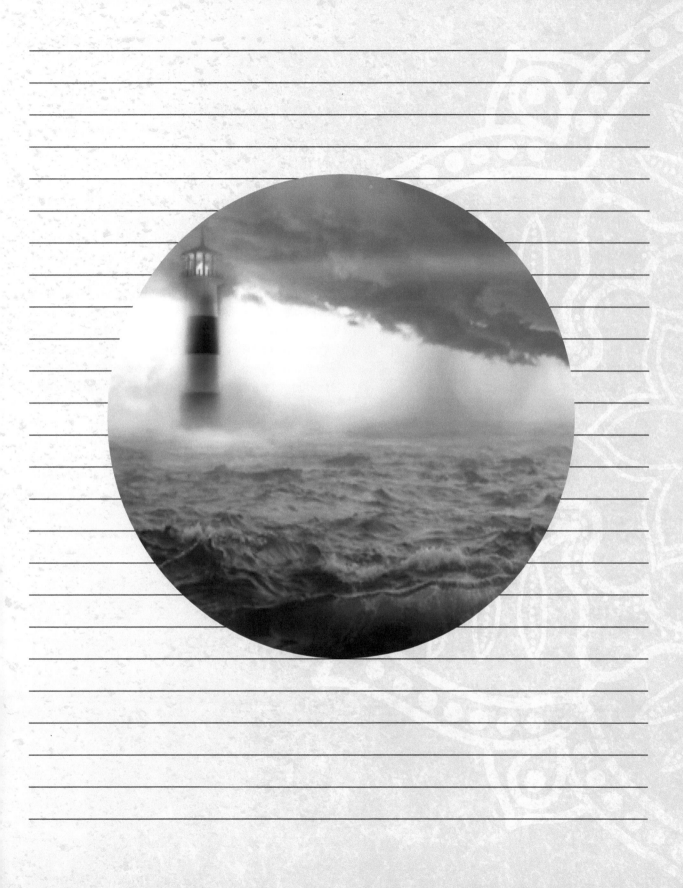

Doing the Work

I feel as though I've put myself through the wringer
Over and over
Learning the lessons
Incorporating new insights
Just when I think "I've got this!"
That's when I tumble down the rabbit hole again

Humbling process
But I can see the wisdom
We only get what we can handle in a given moment
Sometimes the work is too hard
Too much
Too deep
So we go a layer at a time
Sometimes razor-thin
Occasionally we rip the Band-Aid right off
But those moments are more rare
The recovery can be too intense
I think we are meant to weep a little
Heal a little
Take another baby step forward
And the next, and the next

Once I got my mind set that this is my path
That there are always more layers to peel back
It's kind of fun
What shadow am I going to reveal to myself next?

I always feel grateful afterwards
Yes, it can be heavy in the moment
Super heavy at times
But ultimately, lighter
And me - I'm better
I show up as myself more

Thank you to all of my guides
For asking soul-stirring questions
Helping me to explore what's in my heart, head
To simply sit still and focus on a centering thought
Or breathe...Just breathe

THIS is the work
Not the accomplishments I previously pursued
Showing up, to myself, for myself
This is what the world needs from me most

Amy Rodeffer Thompson

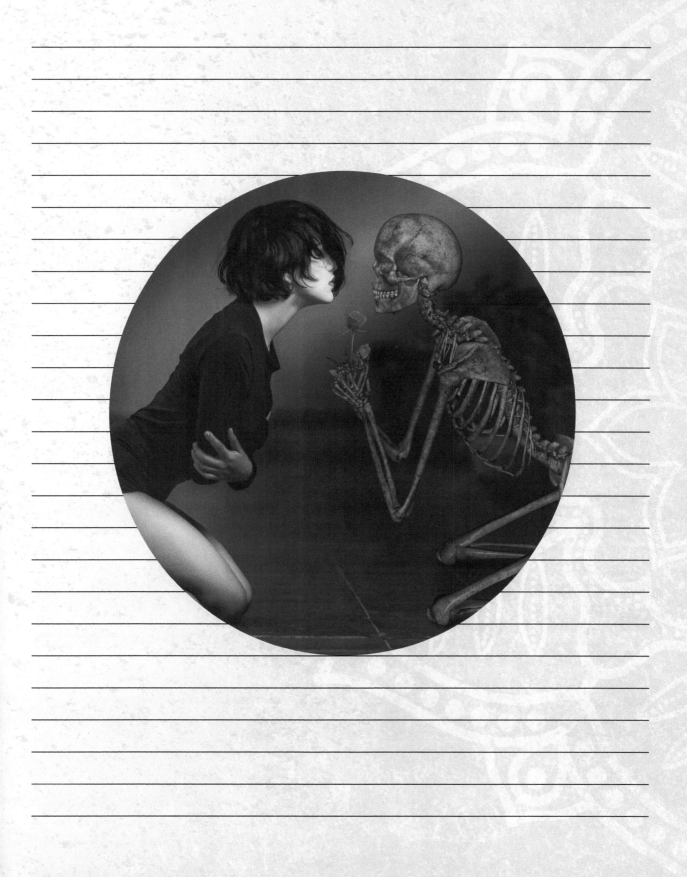

Toil and Soil

I don't mind working hard, never have
Putting in the effort, slogging through the tough times
All part of the process

I think of it like gardening
Lots of variables at play for success
You gotta do the work, or nothing will come to fruition

There can be a point of diminishing returns however
A moment of realization – the soil is off
You've controlled for sunlight and moisture
Tilled, tended, weeded – you've done it all
Yet the output is... lackluster, unfulfilling
This soil isn't ideal for what you're trying to grow

A metaphor that can extend to career, relationships
The lesson applies broadly

So now what?
I've put in all of this effort, for what?
All for nothing?
No, my love. Not for nothing.

There is more soil out there
You simply need to go find it
Now that you know what doesn't work
You have a wizened eye for what might

Is there risk involved? Sure
Grass being greener where you water it and all that
But the choice is yours
Continue to get the yield you are getting
Or cultivate anew elsewhere

I sense your fear
What if I pick wrong?
What if I can't find it?

No time is wasted, every drop of sweat is counted
Wouldn't you rather see blooms in Spring?

Amy Rodeffer Thompson

DIVINE PURPOSE

My actions are anointed by a higher power...

Anointing – the burden-removing and yoke-breaking power of God

...enabling me to move fluidly, aligned to finitely direct my energy for maximum positive impact

Finding My Purpose

I assumed I must have missed class the day one's
purpose was doled out
Sad and miserable to be left behind
I put on a brave face
Faking that where I am is where I am supposed to be
So no one would discover the truth
I had no fucking clue

Eventually, I starting cracking at the seams
The charade became harder to maintain
The disconnect between my life and my elusive pur-
pose became more obvious

Step One – removing others' expectations
That was a doozy
Thick layers of socialization and conditioning
Quite difficult to strip away
I was a disastrous mess there for a while
But deconstruction always is

Step Two – tune in
To myself, to a higher power
Turning off my oh-so-knowing mind
Listening instead to the still, small voice within
Squelched for decades by the bullying thoughts rac-
ing in my head

Even then, still searching for my purpose
Ok, so I now know what NOT to do
What am I TO do then?

A lightbulb moment
Simple questions, looking for trends
My own words, put together into something – pro-
found
Personal and perfectly... me

I begin looking for moments
When that can be felt, observed, lived
A new fascination: where can I steal joy from an oth-
erwise mundane day?
Little moments of fulfillment
Not the brass ring of achievement

Word to the wise –
This version of life is a ton more work
No one to look over your paper
Make sure you got the answers right
You're just... winging it
Doing your best

Walking around in the dark
Arms cautiously outstretched
Trying to avoid bumping into things
Everything feels uncertain, a little scary

Eventually, my eyes got accustomed to
the dim
Moving about with a tad more confidence
A path starting to become more familiar

Funny thing about this part
It'll throw you for a loop, regularly
Just when you think you've got the hang
of things
Another adventure awaits around the
corner

Over and over, the cycle continues
**So if you are looking for predictable and
controllable**
This is not your ride
If you are looking for fulfillment and con-
stant surprise
Welcome to the party

The Universe is always cooking up some-
thing unexpected
But the rewards are so worth it

Amy Rodeffer Thompson

Who am I to Complain?

I get it, the world is a mess
Others have it worse
You look at your situation and think
I have stability
Nothing here sets my heart on fire
But it's fine, I'm ok
I should be grateful for what I have

There it is. The "should" word
Sigh
In my experience "should" has led to a whole lot of bitterness
And I don't want that for you

If you won't give it to yourself
Please accept this invitation from me -
Give yourself permission to dream
What does your ideal life look like?
Hang out there for a while
Don't half-ass it and sketch in pencil
Erasable, anticipating this will get uncomfortable
Or fearful you'll make a mistake
You can't – itis YOUR vision
Color it in, shade it - be bold!
Have fun, for goodness sake
You remember what fun is
I promise, it's still in you

As you gaze upon the vibrant, messy vision you've created
And see the gulf that exists between here and there
Let me reassure you
Blowing up everything and starting over is not required
Those theatrics, while alluring, aren't what's needed

What is required is for you to summon up courage
Good news: small acts of bravery beget more bravery
A whole lot of awesomeness comes with it too

This isn't about "if they would just..."
This is about YOU taking action
For you
All by and for yourself
Because you matter
More than you will ever know

What uncomfortable conversation
can you initiate today?
With yourself, or another
Are you willing to face your own
limitations
Rather than resting upon the injus-
tice of what's been done to you
Where CAN you take control of
your life?

You are allowed to life a good life
Feeling fulfilled is something every-
one is allowed to pursue

Happiness is an inside job
If you are willing to be brave
Start asking yourself some ques-
tions
Be curious, kind to yourself
This may be new for you
And it'll feel weird
But hang in there

True gratitude will emerge
Versus the forced version experi-
enced when we "should be grate-
ful"
The difference is like night and day

Amy Rodeffer Thompson

Quieting the Monkey Mind

Woke up, brain whirling
Spinning through the various To Dos
Endless chatter
Full of should's and have to's

Desire to slow down, find stillness
Giving it up to a higher power -
What do You want me to focus on?

Instant quiet

An image comes to mind
I'm outdoors, a predawn landscape
I notice the gradual brightness
Details of the emerging silhouettes around me

There is an anticipation that comes with daybreak
A mystical quality to the moments before

I linger here, in the in-between
Enjoying the moment
Where there are no expectations
In a state of awe at the beauty of the world
Suspended in a state of receiving

There is no hurry
I stay here as long as I desire

Pausing time
It is here I can center
Enjoying the silence

Amy Rodeffer Thompson

Flexibility

Endlessly recalculating
Adjusting plans
Resetting expectations

Pivot
Turn
Flow

Disappointment

But wait

Better outcomes
Pleasant surprises
Delightful turn of fate

Finding the silver lining
A superpower

Release
Relinquish control
Detach from outcome

Maybe it's me
My consciousness
Too limited
For the incredible alternatives
I was too small to envision

Trust
The Universe has my back
Always
Conspiring in my favor
As long as I let go

Amy Rodeffer Thompson

The Good Kind of Stress

I had a job where were always ON
Crises to solve at every corner
Never any real downtime
My goal at the time -
Make things more efficient
Work smart not hard

Then the pandemic happened
Everything screeched to a stop
Time for reflection
This concept of busyness
Reexamined from an unexpected vantage point

We had purpose
Something useful to do
When that was taken away
That was the loss we mourned

Like an athlete when the season ends
Or the student when the project is done
Initially yes, there is relief that the crunch is
over

But upon reflection
That was the good kind of stress
The kind that shows you what you're made of
Resilience-building moments
Made stronger by working together through
challenge

My intention has shifted
Not to look for my bliss
But rather - what challenge do I want to take on
next?

A new strategy for me
Previous I would have sought stability, security
These past few months have shown me
That's a disempowering position
It puts my fate in the hands of another
And that no longer feels right

I'd rather put my eggs in my own basket
Scary? A little
Do-able? Absolutely

Amy Rodeffer Thompson

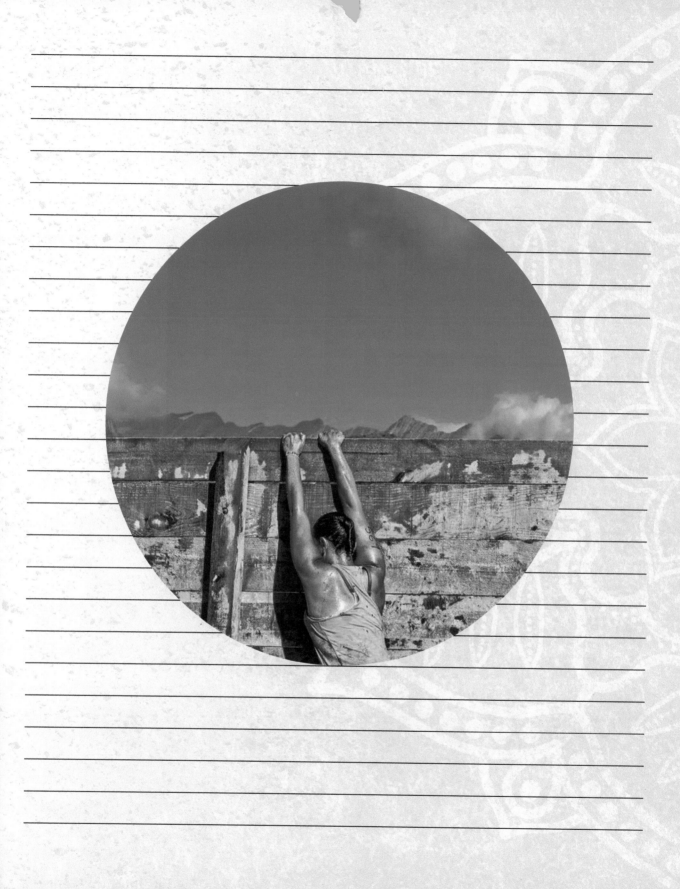

A Moment of Peace

Morning
Light but not yet bright
Slow and sleepy start

Knowing the souls here with me
Trusted
Hearts full of love for me
And me for them

Grateful heart today
Knowing where I've been
Present in the here and now
In a deeply centered way
Feet firmly planted in reality
Heart joyful
A goofy grin

My life is so incredibly good

Sun bursts through
My people are chatting
Sound of surf
Warmth fills me

A moment of peace

Amy Rodeffer Thompson

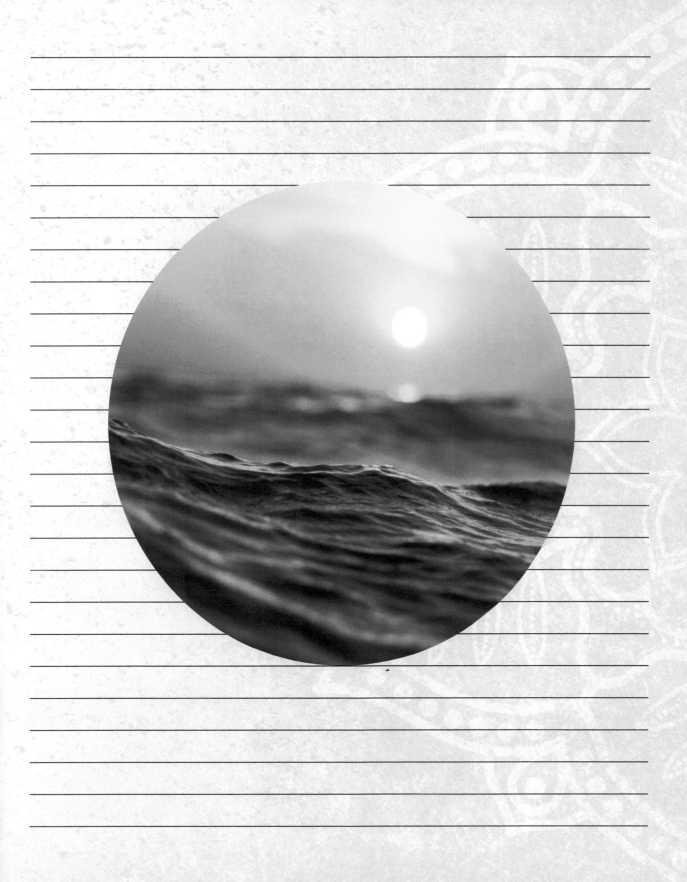

What Else Can You Quit?

I can do many things
Flexible, adaptable
And those skills have served me well
Over the years
I've proven I'm quite competent

Then, a shuttering halt
After decades of constant motion
I finally start sitting still
Waiting for that small voice inside
To nudge softly - go here, not here

I'd ignored that voice for a lifetime
Assuming I lacked an internal compass
A way to find true north

Nope
Had my finger firmly pressed down on the
mute button
Grinding through life
Doing what I was supposed to
Gaining favor by being nice, amenable
Following the good girl playbook

Exhausting way to live, but familiar
On the surface - everything looks great
Inside - vast expanse of emptiness
Why am I working so hard to never feel good?

A difficult scaffolding to dismantle
Infection in all aspects of life
Reexamining old assumptions
Asking of myself - what do you want?

Sense of purpose
A vision for my future
Eventually, things becoming clearer

I am not chasing the almighty dollar for status
anymore
Just because I am good at something doesn't
mean I have to keep doing it
If it drains me, that's probably not where I need
to expend my energy

If you quit something and don't miss it
Perhaps you were done with it a long time ago

What else can you quit?

Amy Rodeffer Thompson

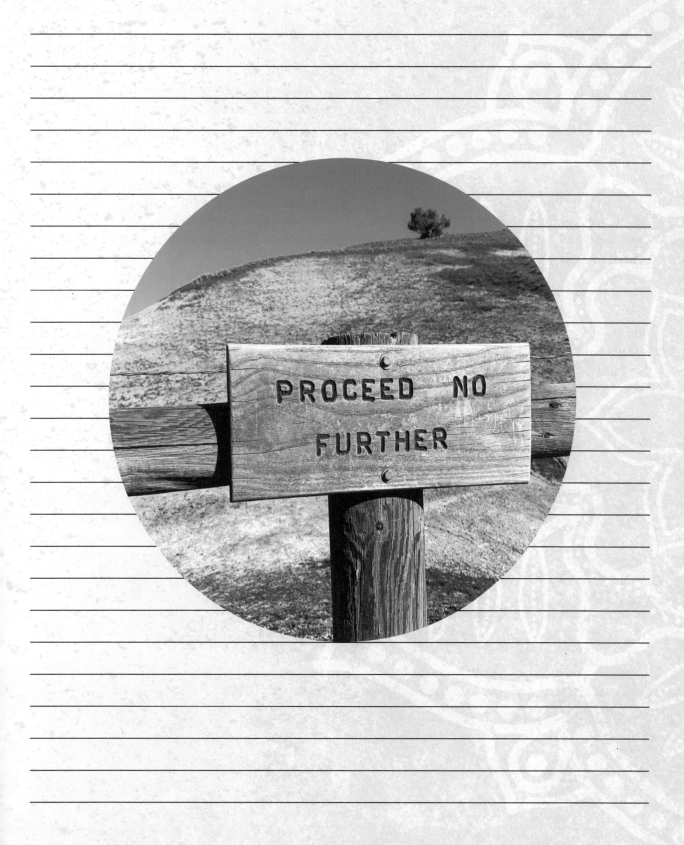

Passion

I assumed for the longest time I lacked passion
Kind of a flat, emotionless existence
Attached to nothing
Trudging along, doing what I was supposed to
Waiting to die

I had a naive perception of passion
Admittedly reinforced by daytime soap operas
The emotional, out of control type
Scary to be around, one word or act away from
destruction
Harmful to themselves and others

Passion sounded interesting but unattainable
Something reserved for the brilliant or insane
I fit in neither camp

Gradually, I got to know more people
Connect on a deeper level
Saw insanity and genius were not required

I met people who had "it"

This spark or something
Lit from within, they had conviction
A purpose, a reason to get out of bed
Of their own volition

And that purpose didn't have to save the world
It could be photography, cooking
Solving a specific problem
Creating a home, lifestyle for their family

My misconception about passion -
The WHAT is less important
It's the WHY
It's all about the why

How many folks are sleepwalking
Trapped in a dull nightmare?
Living a meager existence
That has nothing to do with outward appear-
ances
I know I was
Unlikely I am the only one

Amy Rodeffer Thompson

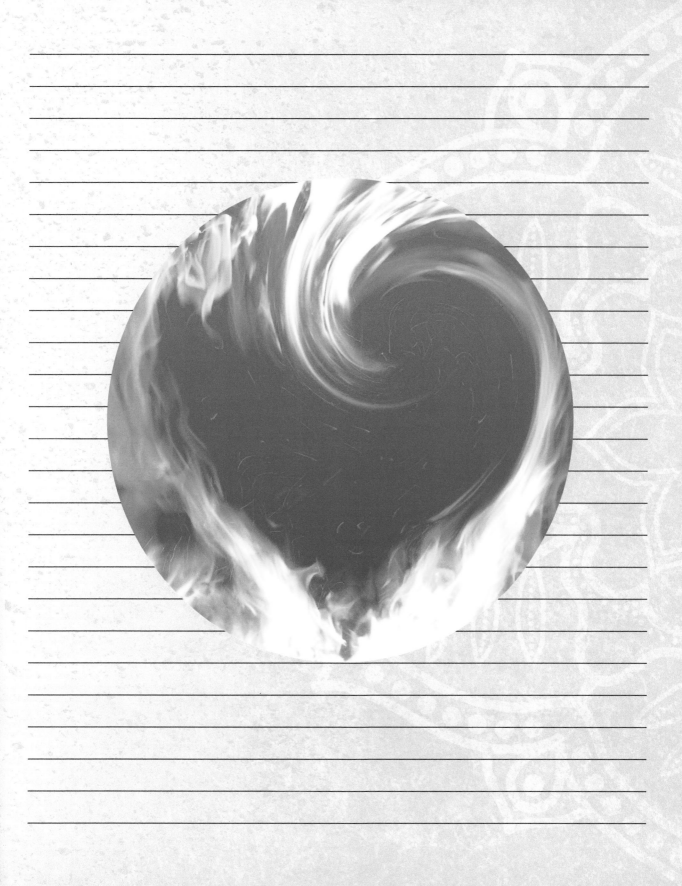

It Isn't Because You Aren't Enough

I think about how hard I've been on myself
Always striving, feeling less than
It occurred to me I was missing the mark
Laying blame at the wrong feet

I wanted to be fit
It wasn't due to lack of discipline
I wanted to be successful
It wasn't due to a lack of hard work
I wanted to be happy in relationships
It wasn't due to a lack of effort

I did have lack, just not there
I lacked awareness
Of what was really driving me
Cracking that code is the truly enlightening stuff

How I viewed my body was contentious
A bitter battle, the mind seeking dominance
Over an uncooperative body
Unaware that integration was the answer
Body and mind, working collaboratively for wellness

My approach to success was adopted from society
Work hard, move up, make more money
I followed the rules, I moved up and made more money
And felt poor as hell
Clueless that with purpose, an entirely new roadmap was possible
One which integrated my talents, skills and desire
And fuels me with confidence

My relationships were viewed from what can I do for others
I had assembled a delightful dream team
But was desperately lonely
Once I started being real and vulnerable, game changer
I began to be aware of the power of reciprocity
And can now feel the love I'd been receiving all along

None of this happened overnight
But there were a few truly pivotal moments
Realizing I am worthy to merely exist
Reconnecting with Source
Dropping the facade, letting people in
Embracing imperfect action
These were my stepping stones

I wasn't lazy or unmotivated
I was focused on things that weren't mine
And that's ok
Maybe I had to focus there to build certain muscles
Muscles I would need to rely on
As I build new ones

Amy Rodeffer Thompson

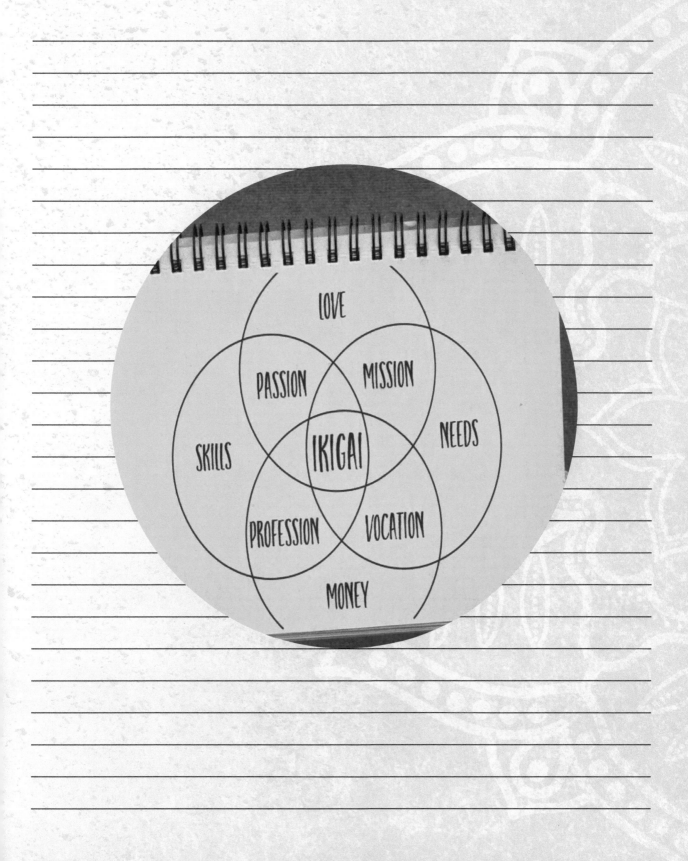

POWER

I am ablaze with a primal feminine fire that propels me forward in pursuit of my passions

(whispers to self):
Who is this person?
I'm excited, and more than a little terrified, to see where this goes... but I'm IN!

Face of a Woman

This is the face of a woman who has found happiness
Sitting in her own joy, in the moment
Fully aware that she has discovered her knowing

This is the face of a woman who is still learning to
hear her own voice
Who talks a good game
But still gets tripped up
By expectations, disappointment

This woman knows she is kind
Knows she is gentle
Knows she can be firm

And she is releasing
The past, things that no longer serve her
Old ideas that kept her safe
But also kept her small

It unfolds over time
Some progress is rapid
Others revealed gradually, slowly
Dawning understanding
Ooh, THAT'S what that meant
Now I see
Deeper understanding

This is the face of a woman who feels conflicted
From the joys of the present
And the comforts of the past, however outgrown

A past where she desperately wanted to be liked
To prove her worth
Beyond a shadow of a doubt

Why can't everyone just be fucking happy for me?
Anger, bitterness, resentment
Defensive, self-doubt creeps in
Why are they trying to steal my joy?!?

Because they are not you
That's what makes you special
Just like their things you do not mirror
Makes THEM special, as well

Appreciate your gifts
Getting upset because they don't share
yours –
That's your work

I don't NEED people to be happy for me
I would PREFER that they are
An empowering perspective
That allows me to soften
Unclench my fists

The alternative –
Be patient
Allowing trust to build
Versus insisting it be bestowed instantly

Let 'em talk
They'll come around, or they won't
Either way, you can stand in your own joy
With or without them

Amy Rodeffer Thompson

I Am OK with That

I see you in pain
I don't relish the idea
It is foreign for me to doubt you, dislike you

I am allowing space for your pain
Too much so at times
Coming from a place of compassion
Understanding that you are hurting

You didn't choose this
You don't have control
That undoubtedly is uncomfortable

And I have changed
I hear you are worried about me
No need
I'm good

The truth is: I am a goddamn lighthouse
You've never seen my light so bright
I've removed the smudges from the panes of glass
It is glorious to step into my power and feel God's
presence in my life

I realize the situation I put myself in was largely
self-induced
I am ok with that
I realize you didn't get the best of me
I am ok with that, too
This is my journey
I don't expect you to understand that
Your path and my path are not aligned

At this point, I merely want to move on
I don't want drama
I have other things to do with my life

It appears you are seeking answers
I have given them to you
Evidently, they are not the answers you wanted to hear

Our dynamic was based on me putting
myself into a tiny box
I'm not there anymore
I'm more than capable of taking care of
myself

Our relationship was unhealthy
I was the one to see it and take action
That is neither good nor bad

I've changed, but only in that I love myself
first
You can cease being worried about me
I'm fine

I've always been fine

Willing to Be Brave

There are moments in life
When we have the opportunity to be brave
Not the heroic, save someone's life moments
Rather, the stare down our own self ones

When the truth is within
And we have the ability to see what is

For me, these are intimidating moments
Where **I am invited to trade comfort**
For raw, honest truth

Feeling quite vulnerable
I contemplate standing on my own
With faith in God and myself - none other
Face to face with blind faith, terrifying
Shedding old paradigms is excruciating work

Am I willing to abandon that which I have
painstakingly built
In order to be truly happy?
My ego despises this question

Am I willing to dismantle my house upon the sand
Start over, from scratch and build upon the rock
this time?

To see that my house is built on sand is heart-
breaking
All of my best efforts, yet the structure is crum-
bling
I resist letting go
Bemoaning what was, what I hoped would be

When I bend and allow the truth in
Collateral damage ensues
A shock to myself and those around me
With time, gentle relief
The rebuild picks up momentum
Many of the old skills are still useful
The structure is solid
This feels right

Looking back, I am grateful I was willing
Not easy work, not by a long shot
Ultimately, I feel lighter
Without the baggage of the falsehoods
Old stories I was insisting were truth
Proven to be outdated, insufficient
For the person I have evolved into

Amy Rodeffer Thompson

Power of Pain

Sometimes we need to get shaken, rattled
To feel a little pain
Because **we were never going to get out of our own
way**

Too comfortable
Too safe

When this happens, we are disoriented
And our eyes are opened
Just a little wider

And we see
Things that were always there
That weren't visible
When we were directing our attention elsewhere

Things that truly matter -
Appreciation
Love
Simple pleasures
Gratitude for what is

It feels foreign
Slowing down
Not running and gunning so hard
Like you are falling behind
Missing something

But perhaps that's the point

Maybe we weren't meant to drive so hard
Maybe we need to chill the fuck out

Maybe the "crazy" ones were right
Maybe the "lazy" ones were onto something

It's scary to challenge the norm
Your base assumptions
The stability you'd come to rely upon

For me
I see that **I had grown numb
Comfortable in my discomfort
I had to feel pain to experience freedom**

Freedom of thought
Freedom of choice
Testing assumptions
Of what is good for me
Right for me

No one chooses pain on purpose
Well, perhaps the truly radical thinkers do
But most of us cave
To fitting in
To feeling secure, at least the semblance
of it
For connection to others

These are trying times
But growth is possible here

What are you going to do with your ex-
panded vision?
How will you emerge once the dust set-
tles?

Amy Rodeffer Thompson

Leap

I feel fears being stirred up
A desire for certainty
Can I trust this?
"What if" abounds

My truth - I know I am fearful
I draw boundaries -
I won't move until I'm good and ready

Once I am all in, I glide
Effortless swift motion
Elegance in action

Right up to the moment before -
Clutching tightly to the edge
Terror in my eyes
No way am I budging

I'm guessing that's no fun for my inner circle
Patiently waiting as I prepare for eminent change

This life of mine
It's weird, but it's ME living it
Old habits of riding others' coattails
Abandoned
Now I'm like a stubborn toddler
Sitting in the middle of my room
Sulking, indignant
Refusing to go

Once I decide, though
I skip the Go SlowLane entirely
And leap, headfirst with bravery

Because my head and heart are aligned
I know that I'll land softly
And that good things await

Amy Rodeffer Thompson

Doing Hard Things

Stretching beyond our comfort zone
Out on that edge
Nerve-wracking stuff in the moment

As adults, it's so easy to get comfortable
Stay safe, take it easy
The illusion of having earned that complacency
Hell, it could even be described as self-care

While running full tilt constantly isn't healthy
Creating moments of bravery is really good for
us
Moments where we fear we may not excel at
something
This is where interesting things can happen

Turning fear into exhilaration is one
The body doesn't know the difference
Scary can be fun, believe it or not

Bravery begets bravery
If I can do this, I'll actually consider doing that
And that turns into another, then another

Days don't pass by like mindless tv
A dull hum of decent but forgettable moments

Starting is the tricky part
Pushing through when it gets tough is the scary
part
What you feel afterwards is the marvelous part

Holy crap, look what I did
I ain't dead yet

When you are in that moment of glory
Look around - what's the next thing?
Start again, before rationalization beckons
Whispering, you've done enough
Relax, take a break
You don't have to do hard things if you don't
want to

When you are throwing yourself your 85th
birthday party
You'll thank yourself for resisting that urge
The stories
Ahh, the stories you will tell

Amy Rodeffer Thompson

FODO

Fear. Of. Disappointing. Others.
I'm making this a thing
For my fellow people pleasers
Co-dependents
I really needed this acronym
Maybe you can use it, too

There I was
In an emotional rough spot
Again
And I was torn -
Between two things

One was merely a safe space
Where I can simply be me
The other was also a loving space
But likely would require a bit more from me

I'd made plans
People were expecting me
I hadn't communicated
I wasn't acting responsibly
I was disappointing someone

My reaction was to drop everything
Soothe, smooth
Assuage the emotions, the situation
Make it right for them
To relieve my guilt

But I didn't have it in me
I was spent
So I sat still
SUPER uncomfortable
And **I let myself choose me**

Felt like I was dying inside
It was so painful
I apologized but was still unsettled
I kept mentally recalculating
How can I make it up to them?
Endlessly assessing my options

But ya know what?
They'll survive
I have established a good track record
Being there - steady, consistent
I'm not less of a friend
For changing my mind
Even if it inconveniences another

I don't owe anyone anything
I choose me
Over and over again

And some days it is painful
To leave that familiar place
That no longer serves me

I presume this will get easier with time
But right now, it's still hard
And that's ok
I can handle uncomfortable things

Amy Rodeffer Thompson

Forgiveness, Not What I Thought It Would Be

I've been working through a lot
Healing old hurts, coming to terms
Thought I'd gotten to a good place
But there were some sticky parts left
Wounds I'd refused to let heal

I woke up one morning feeling forgiveness
No preamble, just forgiveness
The simplicity of it striking

So forgive I did, and the list flowed
A mixed bag of big and awful
Small and seemingly trivial
Every thing I'd held onto
Whoosh. Released from my grip.

I'd been toting this heaviness in my heart
for too long
Now willing to let that shit go

I had already accepted that people are
complicated
Actions coming forth from layers of why
This was something else -
It no longer serves me
To hold onto the bitterness, blame
I choose to release

When I gave myself permission to let go and
forgive
I assumed that meant I'd feel lightness
I did, for a spell
Then a flood of other stuff came up

It occurred to me -
I caused others pain too
Whether purposeful or not
I'm sure those I forgave
Have hurt they've held onto because of me

On their side of the equation
I may very well be cast in a dim light

Ouch

As I sit with this, I feel increasingly agitated
Exposed, vulnerable with this lack of holding onto hurt
No longer having my past wrapped with a neat bow
Firmly defined roles, with me as the morally superior
one

I had gotten comfortable in the role of victim
Fuck, really?

This forgiveness thing sounded really good in theory
In actuality, it feels pretty damned messy

I thought with forgiveness I would set myself free
What I feel instead is the weight of my own arrogance
I had painted a picture of me as a saint in all of this
That's embarrassing and humbling

I'm not as great as I had convinced myself I was
Well shit
Now what?

Sitting in my discomfort
I feel like a crazy person
Not sure what's a reaction to discomfort
And what's a real part of me seeking change

I'm just going to sit here
Shed the tears that need to be shed
Until I figure out what's next
I'm certainly not going backwards
But I don't know what forward looks like
Yet

Release... tears... ah-ha moment
I am imperfect, and powerful
Both of which I had rejected
Wearing a victim jacket that never really fit
Trying to be perfect was part of the playing small pack-
age
And victim was the excuse lens
Through which I maintained my squeaky-clean record

Imperfect and powerful
Both make me somewhat uncomfortable
Probably because they are true

Amy Rodeffer Thompson

Self-Sustaining

Struck by an ah-ha moment
An insight from out of the blue

I am self-sufficient, self-sustaining
I can absolutely take care of myself
And I will survive

But in order to thrive
I require others
Interdependence
That's my next chapter

Leaning on others
A wisely curated inner circle
That are reliable, responsible
Who can expect the same from me

We are messy, complicated
Fucking good at what we do
Unafraid to show up as we are
However that may be

And it is invigorating
Exciting, to be a part of something
Authentic, inspiring
The Universe giving us the nod
This is good - keep going

It's good to know I am self-sufficient
But now I'm ready to thrive

Amy Rodeffer Thompson

Excavating Fears

Where else is this showing up in your life?
I've heard a friend kindly ask this question of others
Gently probing for self-reflection

I used to believe I had everything under control in
most areas of my life
I focused on specific areas where I saw issues
A game of whack-a-mole
If I can just get this one part dialed in
All will be well

Sort of true, also not
I had things together within a fragile, rigid container
Resulting in predictable, safe outcomes
That left me unfulfilled and miserable

Now that I've embraced not living small any more
I have some defining to do
What does "good" look like?
How will I know if something is "done"?

I'm rebuilding my house
Digging to form a solid foundation this time
In the process, I'm unearthing more fears
Seriously? More...?
Fine. Let's pull 'em out and take a look

Fear of not pulling my weight
Terrified I'll be an unfair burden to others

Fear of being less than
Accustomed to buoying my ego with condescending
superiority
A quiet, ugly truth

Chaos - a word that has been coming up a lot for me
lately
Fear of taking myself seriously
Hiding behind a woe-is-me attitude
Letting things slip into disarray
A signal to myself that I don't matter

Dusting myself off
I see these fears for what they are -
Coping mechanisms which once served a
purpose

I have the option to reassess now
See what still fits
What can be evolved, shaped into some-
thing that suits me now

I am fortunate - I have the luxury to de-
fine these things for myself
I have support from others as I define my
new wants

How lucky am I?
To have this life

Amy Rodeffer Thompson

The Easy Life

I thought life was supposed to get easier at some point
The struggle was "going somewhere"
That I would "make it" someday

Evidently not

Instead, good and bad stuff are happening concurrently
Intermingled highs and lows
No straight line to anywhere

What a relief
This is MUCH more fun

I am full of purpose
Relying on divine intuition
Keeping attachment to outcomes minimal
Having a blast every step of the way
Financially less secure, on paper
Yet feeling incredibly abundant
Sure that I am on the right path
No definitive idea where it's leading

I am blissfully happy in my relationships
While battling inner demons regularly
Experiencing intense gratitude, to the point of tears at times
Feeling truly seen and heard
Interspersed with intense moments of insecurity, fears
This tension keeps me from getting too far off course
No space to linger second guessing or getting too upset
Far too much inner work to heal and awesomeness to enjoy

I am drawing boundaries with others
Holding gentle, kind, and firm
Seeing where I am a judgmental asshole
Feeling sadness, loss because of the changes I've created

My life before was that of a duck
Gliding along a glassy, unperturbed surface
Furiously paddling beneath
Never showing the private struggles, the exhaustion
Now, I'm more of a young bird learning to fly
Crashing comically for all to see
Shaky starts, sure, but undeterred
Beautiful, effortless mobility within reach

I feel free
Free to mess up and give myself grace when I do
Free to not know and doing anyway
Free to stand on my own, and with others

**Life is fun in the here and now
Because I am no longer waiting for it to get easier later**

THIS is the easy life

Amy Rodeffer Thompson

OPEN

On our own, we break under the pressure
But, with the Lord, we bend

- Corinthians 10:13

Awake Now, and All Hell is Breaking Loose

Insecurities
Previously unarticulated
Now running rampant, like a pet off their leash

And anger
Sharp, quick
Backed up by injustice

How dare you
Not validate how smart I am
How mature I am
How together I have it

Undertones of terror
I KNEW this would happen
Told ya so

Shouldn't have let your guard down
Opened that door
You were fine before
Why did you need to go there?
Why?!?

Careful what you wish for
Bitter
Resentment
On the cusp of retreat, pulling back

And then

Remembering

Emotions are fleeting
To ease into it
Embrace the crazy
Own that shit

Start to chuckle at yourself
You ok?
You know you are *going* to be, right?

It's ok, my love
You are multi-layered
You'd just been hiding this one
Fold it in

You are still awesome
And you never were perfect

Embrace the messy parts, too

Amy Rodeffer Thompson

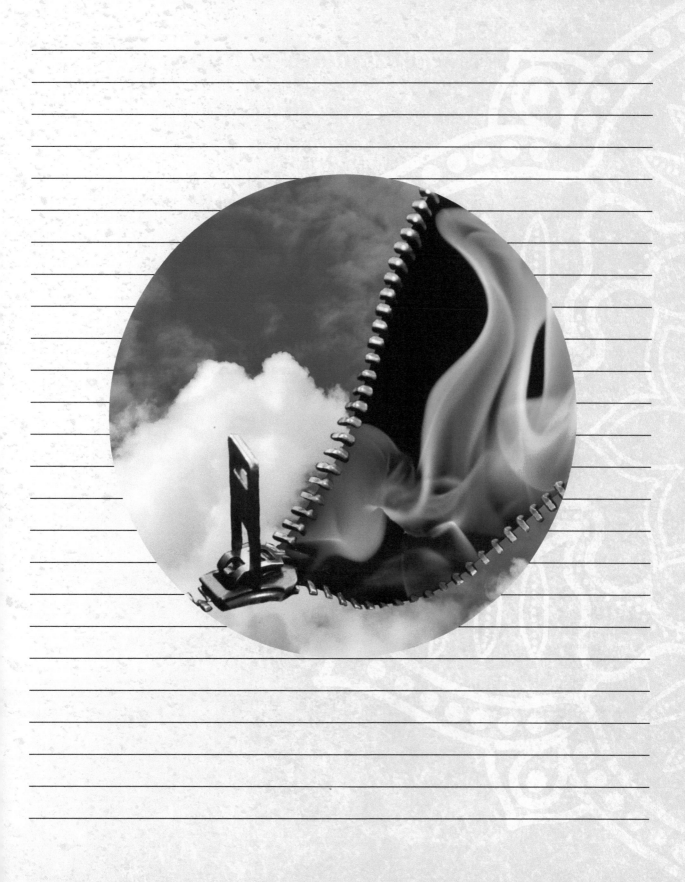

Abandoning Perfection

I give up
It's too hard
Trying to be perfect

In my quest
When push came to shove
I was the odd man out
Every time

If it came down to it
I would sacrifice myself
In the pursuit of harmony
Not letting others down

I didn't realize it at the time
But I was constantly disappointing myself
Feeling guilty for having my own needs, wants,
priorities

No one asked me to play the martyr
I did get folks accustomed to it, though
So a recalibration is required

I am no longer striving for perfection
I have limited experience communicating
Competing agendas, choices, options
Because previously it lacked ME
MY desires, interests

I made others feel like I was always available
Because I was
An unsustainable expectation
Unhealthy for all involved
Enabling with a capital E

So here we are
And not much has changed
I want to make others happy
Still true
Now I'm adding myself in the mix, too
And that may feel weird to others
Who knew me without that variable

The empowering part is letting go
Letting go of the outcome
The parts I cannot control

Tapping into my center
Getting softer each time I get clearer
The benefit of **choosing me**
Instead of forsaking me

Amy Rodeffer Thompson

Squeezed Between

At that age where your energies are pulled
Raising kids into adulthood
While also helping parents into aging

I observe my friends
Frayed from the strain
Worry cast in all directions
This is a particularly exhausting time

Both parties crave their independence
Yet both need watchful attention
Keeping them out of harm's way

For the caregiver, there is no Out of Office
The phone calls can come at any time
Heart racing, what is it this time?
Dropping everything, racing to deal with the latest surprise

The tricky part is how to refuel the tank
Me Time is for the betterment of everyone
Yet those who need it are too damned tired
Too tired to relax, to blow off steam
Creating that time requires effort they don't possess

There are no easy solutions
Only compassion
This is a hard thing
I know your heart is heavy

I'm here, sitting with you
As you do this hard thing

72 Amy Rodeffer Thompson

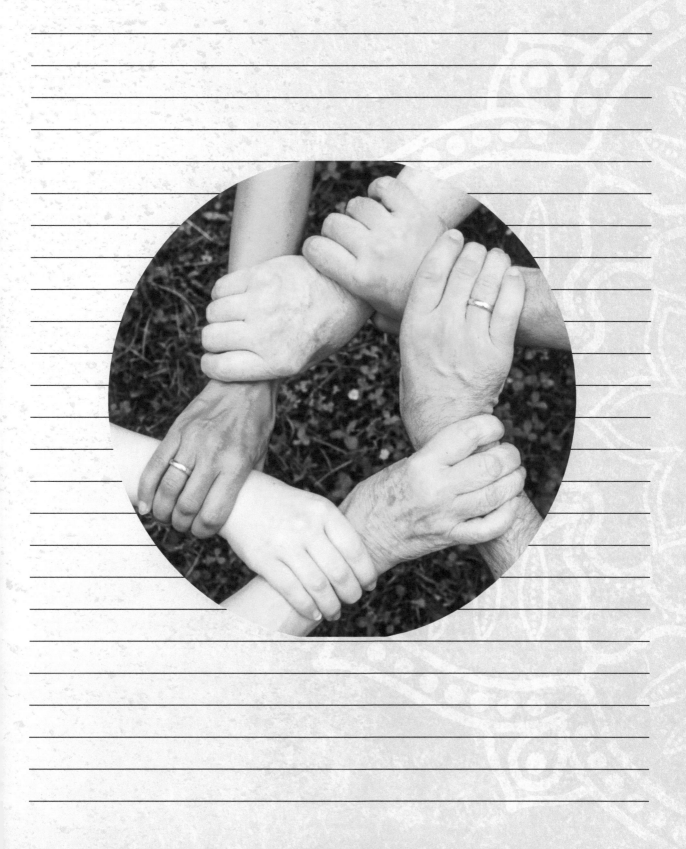

Shame

When I feel it, I withdraw
Nothing to see here, please move on

I isolate, diving deep into a spiral
Of self-loathing and recrimination
How could I have been so stupid, careless, clueless?
Never productive and never-ending
The narrative is bleak

These are the **secrets I've held deep**
Miserable companions on a shitty journey
Destination: nowhere
Nothing to do but ruminate on my bad choices

Occasionally I've surprised myself
Bringing shame into the light
Sharing my most horrible truths with another
End result: nothing dramatic
Which is surprising in and of itself
I'd assumed I would perish
Dying of embarrassment, a real thing in my mind
Alas, I'm still here

Shame sucks, no way around it
When it happens, I go to the familiar -
I make myself small and quiet
A futile attempt to distance myself from the pain

I know better, but it still happens sometimes
I now have experience dealing with it
Having trustworthy support helps
Facing the shame and pushing through helps even more

I don't think I'll ever be done discovering
More stupid things I've done that I feel badly about
Owning my shit is a challenge
But the lightness on the other side feels pretty damned good
And that's enough

Amy Rodeffer Thompson

Compromise

When I told her she should hire me
She said I thought you wanted to work in an industry where you made a difference

When I graduated college
I assumed I would be working to save the planet
When corporate America came calling, I accepted
My roommate told me she felt I was a sell-out

I find myself in judgment, self-recrimination
They were right!
How could I be so blind, lying to myself?

Baby girl, be kind to you
You made HELL YEAH choices in those chapters of your life
Don't rewrite history with you as the villain
You have always been flexible
Seeing opportunity in imperfect situations

Did you remain too long sometimes? Sure
Did you ultimately decide it was time to shift gears? Yes
Doesn't make those experiences any less
You've been growing, learning
It's only natural that your interests could shift as well

It is unrealistic to think you had all the answers
That you could have had more resolve
To hold out for something more ideal

You were doing the best with what you had
Your limiting beliefs made a box
You kept yourself safe playing in that box
Until it was time to explore beyond
A cycle that repeats, the boundaries gradually expanding

Perfectly imperfect
Shake your head at your naivety from time to time
But really, no need to linger
There will be more of these ah-ha moments in your future
You will outgrow today's limitations someday as well

Amy Rodeffer Thompson

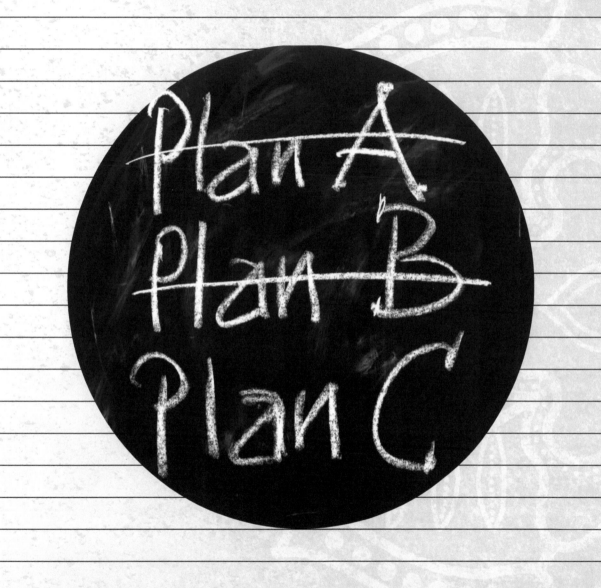

Grief is Weird

There are a lot of things in life that get better by doing
Grief isn't like that

If I am ill, there are steps I can take to regain wellness
If I am ignorant, I can seek information
With grief, it simply... is
As a loved one supporting another in the throes of it
Even more...awkward

When tragedy strikes, the script unfolds predictably

Oh my God. What happened?
As if knowing those details makes any difference
Yet our brains need a place to go
Desperate to make sense of the illogical

I'm so sorry. Genuine, heartfelt words
A teacup attempting to empty an ocean of tears

What can I do to help?
Sincere, yearning to be of service to those hurting so deeply
The grieving, too overwhelmed to even respond

Being present feels right
Little helpful actions – come, I made you something to eat
Presenting simple decisions – A or B?
Gentle reminders of self-care – here, take a sip of water

Being open also feels right
An invitation – be whatever you need to be right now
Crying? I've got a tissue for you
Wanna talk? Happy to listen
Want to numb out for a spell? Absolutely

I have no clue if any of this is right
Glennon Doyle suggested once to "just show up"
And I took that to heart
It's better to just be there, imperfect and all
Because no one should feel alone in times like these

Amy Rodeffer Thompson

There I Go Again

Trying to make myself small
Little habits, hard to shake

It used to be worse, much worse
Now I feel a twinge
A split second of consideration

Sometimes I catch it, others not
Now I notice the discomfort
The pain that invariably comes

I'm aware of my power now
To be less is an insult
To me and my Creator
So I am mindful to cut that shit out
And be gracious with myself when I forget

Healing is a process, fits and starts
Awareness grows with practice
Some moments blindside me
Another area to explore, be curious
What was that all about?

Such compassion
For little me

Amy Rodeffer Thompson

Tug of War

My ego and I
We've been battling lately
Fiercely

Ego suffered a major blow recently
Retaliation has been swift
And disorienting

Self keeps circling back
Acknowledging
Ego's strength
Softening the stance
With compassion

Not a straight line
Ego is familiar
Seductive
Alluring

Self is unsteady
Taking the wheel
With shaky hands
But true

I'm putting in the work
Day by day
Moment by moment
Checking in
Seeing what feels right
Sorting out what isn't
Until I land upon solid ground

The signals are getting stronger
When I'm not aligned
With Source
Sometimes it takes a bit longer
To recognize I've fallen
Back into old ways
Familiar ones
But not ones of my choosing

Amy Rodeffer Thompson

Wokexhausted

Adjective

1. completely or almost completely depleted of mental and emotional energy directed towards being alert to injustice in society

This happens from time to time
When I am working so damned hard
To be open-minded
Self-aware
Expansive
All of that evolved, be-a-better-version-of-you stuff

It becomes hard to recognize which way is up
Everything I think and feel, under my own microscope
Each moment transformed into a lesson to be learned
Earnestly working to rewrite old tapes, stories that no longer make sense

I hit a wall
I cannot process any more

So I pause
It gets worse
Realize I'm being extra judgmental of others
WHILE working on my own biases
Good grief

Come on, girl.
Lighten the hell up.
All of those adages about take care of yourself, rest...
They meant you, too, darlin'

Put down the TED Talks and simply read for pleasure
Reminisce with an old friend
Relax the grip on your self-appointed task of making sure everyone else is ok
Do nothing for an hour. Like actually nothing.
See how that feels.

Turbulent times make you uncomfortable
You are going to reach for what feels familiar
Don't beat yourself when you feel judge-y
It's normal
Try to remember to slow down and respond vs react
When you mess up - which you will - simply apologize
You are doing your best

JOY

The sound of a toddler laughing...

... wind chimes stirred by the lightest puff of wind

It's Ok to be Happy

Did you know
You are allowed to feel true happiness
Even though it feels like the world is falling to shit?

Seriously, it's ok
No need to qualify or justify it
You are allowed to simply... be happy

You can fall in love
You can begin new ventures
You can let go of that which no longer serves you
You can cut yourself loose and live a little

Yes, there is much suffering in the world
One can be aware and sensitive to it
While also flourishing
These are not mutually exclusive

It doesn't make you an asshole to be happy while others are not

There is never really a good time to be happy nor sad
There is simply opportunity and free will
How do you want to feel?

I feel radiant today
There, I said it
Absolutely fucking radiant
Unapologetically joyful
Overcome at times with gratitude
For my beautiful life and the people in it

There is no prize for greatest suffering
We get to choose
How do you want to feel?
I choose joy

Amy Rodeffer Thompson

Beauty – It's an Inside Job

I've struggled throughout my life
With the face I present to the world

Starting from physical attributes
It seemed others had it going on
While I was at best average, largely forgettable
I was too much of this, too little of that
I would observe others wistfully
Awestruck by the unattainable

Flawless skin - how confident they must feel
Thick beautiful hair, Rapunzel in real life - how magi-
cal
Athleticism - to move like that would be so freeing
Man, they are so lucky

Fashion? I had no interest
No confidence in my competence
What would be the point
Of drawing attention to myself anyway?

I begrudgingly participated a little
Just enough to not stand out
Clothing, makeup, hair
Gliding beneath the radar

Believing myself above such trivial matters
Judgmental of others -
Those with the passion, talent to create
Numbly concluding I didn't care
Content to believe my own lies

But feeling the disconnect in my logic
A sense that I'm missing something
There must be a reason so many people feel empow-
ered
Having their own unique style

I tried to force it - demanding of myself
To define my personal style, NOW
No dice. Hollow exercise in futility.

Then one day, I started to give a shit
Set a goal to quit playing amateur
And be the real deal
Slowly but surely, I began to notice
The person in the mirror before me
I genuinely wanted to enhance certain
features
Feel even better in my skin

The reason I didn't care before
Was because I didn't see the value in ME
The spark that is me was obscured
Concealed by my own limiting beliefs

Thankfully that pilot light never goes out
Always there, always on
Sometimes just less visible

The beauty within
That is what can be enhanced, further
magnified
You, with stuff that makes you even you-
y-er
That even sounds fun, right?

Amy Rodeffer Thompson

Compatible Shit

Relationships are fascinating
Such a delicate balance
Self and union
Interdependence with another

Those who come from struggle
Sometimes are challenged to trust another
Those whose parents are exalted upon a pedestal
Can struggle to find the perfect mate to meet that
standard

I truly believe it is possible
To find the right kind of someone
And it's not actually all that complicated -

The work is to simply do our own internal work
And find someone who's shit is compatible with our
own

I know, glamorous
The Hallmark Channel will be calling any day now
But I'm being sincere

We ALL have shit to deal with
Every single one of us
And it is still possible to find a partner
With whom we can thrive
One who will gently nudge where you need it
Be compassionate as you work through the hard
moments
Appreciate you for the absolute gift you are to the
world
And call you on your bullshit when necessary

With this imperfect union
You will still annoy one another from time
to time
Disagree and piss each other off
Yet, it can be done
If you set the bar at compatibility
When it comes to the shit

Not a fairy tale ending
But with the right person
It can feel like one

Amy Rodeffer Thompson

Please Don't Dim Your Light for Me

If you have joy, I want you to feel free to share that with me

I've lost my job
You are having a record month
Let me celebrate you achieving your wildly ambitious stretch goal

I'm downsizing my life
You are buying a dream luxury item
Let me celebrate you prioritizing yourself for the first time ever

I'm feeling isolated and alone
You have found love when you least expected it
Let me bask in the radiance of your new relationship energy

I am joyful
Perhaps in spite of all outward appearances
Because when everything looked "fine" before
It 100% was not
What a peculiar irony
I had to lose it all to find happiness
Head scratcher why **I was working so damned hard to be miserable**
Couldn't get out of my own way, I suppose
Holding compassion for myself on that

These days I spend my time in gratitude
My windshield is SO much larger than my rear-view mirror
What's before me brings such joy
Leaving me oodles of capacity to share yours

So I invite you to bring your successes
I'm your cheerleader
Happy to be happy with you, friend
Let's be the light for one another, fellow lighthouse

Amy Rodeffer Thompson

Safety Net

It was a little thing – taking a day off
Sigh. Time – my Achilles heel
A familiar hang up for me

In relationships, this gets magnified
Guilt over not spending time with
What are we doing with that time anyway?
I could be getting shit done!
I've lived through this cycle time and again

When no plans are set
I give myself permission – business as usual!
Schedule-craving creature of habit that I am
Then the time is upon us
An unpleasant discovery
An emotionally charged conversation
Expectations – yup, there they are

This time, however, I remain the observer
Ok, I hear you
I'm sure we DID talk about this before
I blanked. I'm sorry.

Also: we hadn't had the important "how you feel
about 3-day weekends" conversation yet
Said in a playful tone
We smile
And laugh at our folly

It occurs to me –
How beautiful to give one another a pass
"You should know"
What if that phrase never passed our lips?
What if we always treated one another like a delight-
ful mystery?

The desire is support
What if there is another way to get it?

I picture a trapeze net
It's inevitable – I'm going to fall
That's what happens when we pursue
hard things
I'll get myself out of the net once I've
licked my wounds
In the meanwhile, I'm safe here
There is give in this net, softening the
landing
And it's grounded, secure

The fun is had above
Where it's thrilling and scary and exciting
Lying on the net I assess
What happened, what can I do better
next time
I gather my strength to climb the ladder
once again

I am really digging this idea
Giving and receiving support in this way
Leaving room for each to grow and evolve
Space where figuring one another out can
remain fun

I have given my partner permission to call
me out when I forget
I cannot expect anyone to read my mind,
nor me theirs

My safety is in the net

Amy Rodeffer Thompson

Elegant Woman

I see you, she who carries herself with such grace
Making it look effortless

Once one gets to know you
It becomes clear there is more than meets the eye
This is not luck nor fate
You are like this on purpose

Seemingly simply demure and agreeable
While extremely perceptive and thoughtful
Nothing passes you by unnoticed
Without judgement, genuinely curious

I see you - deliberate and all in
To life, and all facets of it
Family, friends, work, home, hobbies
No area left unattended

Unlike some, who strive for perfection
From a place of lack or desperation
Yours is sprung from a well of knowing that this moment is sweet
Because you know firsthand it can be fleeting

A modern-day interpretation of the hero's journey
An act of quiet rebellion to be one of the good guys
Choosing to be resilient rather than resentful
In a world full of those who don't see beyond cynicism

Conventional wisdom would overlook
The power to harness pain, disappointment, loss
Turned into purposeful love and dedication
That's serious sorcery

I see you and am grateful for you

Amy Rodeffer Thompson

Good to Be Grown

I delight in things
That seem weird to others
But they are very real to me

Indulgence
Intense gratitude
Simple yet intensely healing

The flavor of my Chapstick
When I can still taste it when I wake up
It means nothing is wrong
I am not sick
Mouth-breathing all night
As I spent many long weeks as a child

A full gas gauge shown on the dash of my vehicle
I feel a wave of abundance, every time
As if I won the lottery
Simply because I could afford that luxury

Literal tears streaming down my face
Thinking about those tiny moments
When I once felt so small, powerless
How big and powerful I feel now
Tears of appreciation

No trauma, just indelible impressions
Left upon a young soul
In stillness I savor the comfort I can give younger me
You are safe
You are well
You can provide for yourself

A beautiful moment
To reflect on how good it is to be grown

Amy Rodeffer Thompson

Do you understand what you bring to the world?

You bring a buzzing energy
A super nova
Everyone around you gets caught up in it
Like a tilt-a-whirl
Tossed around, giggling gleefully

Your ambitions are hard core
A role model
Across all aspects of life
Aspirational well beyond those you know
Your actions speak volumes
Others notice, and remember

You are a special kind of do-er
Pursing your interests with laser-like focus
Sprinting headlong into acquiring more knowledge
Applying it with discernment
Ever focused on betterment

Your laughter
Anyone who has encountered you knows it's distinc-
tive tone
There is more than meets the eye there
You embody levity
Taking life quite seriously
While finding humor along the way

Underpinning it all
Your heart
True north to your moral compass
Loyal to the point of pain
Genuinely giving
Seeing that this - love - is your legacy in this world

I hope you understand

The world is grateful for you
Appreciates your gifts
Looks forward to what you are bringing to life next

**We couldn't have even envisioned want-
ing someone like you**
It would have felt like asking too much
This particular combo, this specific inten-
sity
Too good to be true
You are something special

Amy Rodeffer Thompson

Perfect Sunday Morning

Gently stir to wakefulness
An auspicious empty spot next to me
He's already up, letting me rest
Awash in gratitude

The luxury of missing someone
Something many probably miss
The past year of pandemic forcing togetherness
In an artificial way

I am learning to truly enjoy interdependence
It looks different for everyone, certainly
We are figuring out our version

Internally, I'm observing the tension
Egoic mind still yearns for what is mine
Loving heart basks in diving deeper yet
Intimacy that spans from giggles to orgasms

As the world opens up, we engage with others more
A new side of each of us revealed
Enlightening, maddening, another perspective

I feel judgment flash
Ahh, there it is - the old controlled persona
Quick to condemn acts as inappropriate

This morning reminds me of the importance of
solitude
It is here that I rediscover gratitude
The critical mind passes the baton
To the loving heart who sees

Life is very fucking good
As I lie here in a warm comfortable bed
Soft sounds of rain outside and friends
having coffee in another room
Gleeful in my private moment

These are the moments when I remem-
ber
My life is amazing
I have all I need and much of what I want
My challenges are merely invitations to
grow further

In this moment I feel recharged
Equipped to face my judgment
Figure out this interdependence thing
Because it's a dial, not a light switch
And I get to control it

Amy Rodeffer Thompson

Good news: I Still Like You

We are 6 months in, and I still like you
It seems as though you still like me too
That's good

We're past that In Love phase
New relationship energy has leveled off
Things that maybe once were cute are likely
irritating now
Routines are established

I love you now more than ever
Loving-without-holding-back kind of love
I leave nothing in the tank
I give every bit of love I have for you
Because I want to
It feels good to me

Neither of us knew marriage could be this good
Grateful every day we are here
In the company of someone who knows their
worth
And sees the value in the other
A delightful find - someone comfortable in their
skin
And present, in the moment

This time spent hasn't been without challenges
Even newlyweds are not impervious to it

Yet not a harsh word has been spoken between
us
Even more important to me: tough conversa-
tions have been had
Seeds of resentment have not been allowed to
grow
Frequent tending to this garden
Plucking weeds before becoming entrenched

That's the work
The daily maintenance which makes for a solid
foundation
One that lets us be... whatever we are in the
moment
Joy and laughter and playfulness and apprecia-
tion
Tears and frustration and disappointment and
struggle
All are welcomed here

Life is fun with you by my side
I don't have to be anything other than what I
am: awesome
You are so lucky
As am I

Chrissy McVie stated it so eloquently -
You Make Loving Fun

Amy Rodeffer Thompson

Afterward

"Good news: small acts of bravery beget more bravery"
- me

In case it isn't clear by now, I used to be a very fearful person. I was reticent to do much of anything that couldn't be rationalized or justified. Not a lot of joy living that small. Now, I still feel the reluctance, but usually go ahead and do the scary thing anyway. It's interesting being on this side of living.

The decision to publish this poetry journal is one of those scary things. I surround myself with people with more experience being brave than me. That helps.

A list was brainstormedof people to reach out to for endorsements. The process of getting endorsements was a beautiful opportunity to test out bravery skills: taking the time to craft a personalized, sincere message; thinking BIG; getting creative; and not getting attached to outcomes – all I could control was the ask.

I emailed Danielle LaPorte's team with a genuinely heart-felt request to see if she'd be open to giving this book an endorsement. She wrote me back. Personally. I felt like I'd won the lottery. She role-modeled what it's like to be graceful in setting boundaries in that little email: she was under a deadline of her own and couldn't commit but wished me well. In hindsight, that was an even better gift – if I had gotten the yes, I wouldn't have received the lesson in her example. Sending big hugs to that beautiful human.

My business partner Michelle Burke is well-versed in bravery, so she hand-wrote a letter to the Dalai Lama because we were so inspired by "The Book of Joy" and we figured... why not? Let me say that again: Hand. Wrote. The. Dalai. Lama. Yes, Michelle is delightful that way. A member of His Holiness' team replied and thanked her "for your beautifully handwritten letter." They didn't endorse but COME ON – that's so flippin' awesome!!

Surround yourself with brave people and interesting things may happen. Be brave yourself, and you can be the author of those interesting things.

Acknowledgements

Michelle Burke is why this poetry journal is in your hands right now. Encouraging me to share this poetry broadly when it first began to flow from Source –a terrifying concept to me – shemade the creation of this book both a priority and a reality. I lack sufficient words to express my gratitude for your vision and support, Mic.

Don Thompson, for doing the work within you, so I can be free to do the work within me. I choose you, and continue to choose you, gleefully and happily. Thank you, my Love, for simply being you.

Shannon Roberts for your support and incredible generosity through my Dark Night of the Soul.

Sneha Bhatt for the fantastic phrase which ultimately became the title of this book.

My incredible network of wonderful friends for knowing I was awesome long before I was aware of it, and who stuck by me until I realized it myself. Y'all are a patient bunch.

Every writer who penned words that touched my soul – I am a better person thanks to you. A special thanks to those who were so gracious to provide endorsements in support.

To all the photographers, illustrators, and graphic designers whose work is featured in this book – thank you for making images available to the world that so beautifully complement the words paired with them.

And most importantly, thank you to God, with whom I co-created every word.

> In the same way, let your light shine before others, so that they may see your good works and give glory to your Father who is in heaven.
>
> - Matthew 5:16

CPSIA information can be obtained
at www.ICGtesting.com
Printed in the USA
LVHW071532221021
701074LV00002BA/2